sculpture projects muenster 07

Edited by *skulptur projekte münster 07*
LWL-Landesmuseum für Kunst und Kulturgeschichte, Münster
(Westfälisches Landesmuseum)

Text: Frank Frangenberg

Verlag der Buchhandlung Walther König, Köln

Preface

In the summer of 2007, *Skulptur Projekte* will be staged for the fourth time in Münster. Since 1977, artists from all over the world have been regularly invited to develop their works in the city. With the first presentation of nine "projects" in the context of the exhibition *Skulptur 77*, an impulse radiated out from Münster which in subsequent years made the city into a worldwide accepted reference for a differentiated and continuous debate on the relationship between art, public space and the urban sphere. Thirty-nine sculptures distributed in the urban space not only give evidence of the preceding exhibitions but also have turned Münster into an open-air museum for contemporary sculpture in public space, even during the years between the exhibitions. In the appendix you will find a city map listing all the works of this year's exhibition, including those which have been permanently installed.

During the relatively long time spans of ten years, the urban

structure has undergone continuous changes as a result of conflicting global and local developments. Public space has gone through new and different interpretations. In response to this process, the fine arts have reinvestigated their concept regarding their space in the city. The artworks reflect this investigation of changed conditions. Time and place are background factors against which the sculptures have to be read.

skulptur projekte münster 07 will reinvestigate anew what contemporary sculpture can be today, how it articulates itself medially, socially and artistically, and what influence it exerts on our understanding of public and space. The thirty-four artworks presented here have emerged out of a dynamic process deriving from the artists' direct confrontation with the place. During their numerous work stays in Münster, the artists have discussed their concepts and further developed them in conjunction with various municipal institutions, which assisted as important information sources.

The short guide introduces the projects in alphabetical order. Using the map you can create your own tour to visit both the new works and the sculptures installed permanently from previous exhibitions.

Frank Frangenberg has written the precise and short descriptive texts introducing each project. We would like cordially to thank him and everyone else who made the exhibition and the accompanying publications possible.

Brigitte Franzen, Kasper König, Carina Plath

Content

Artists

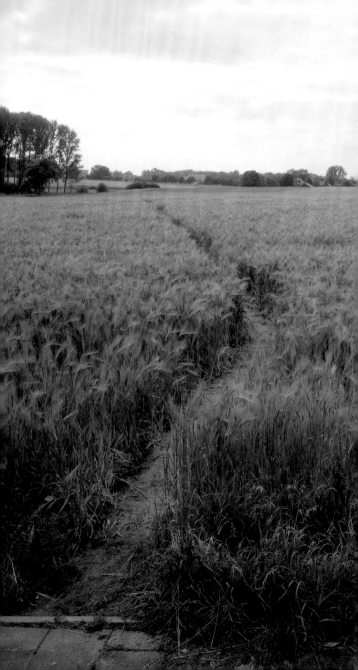

Pawel Althamer
Ścieżka (Path)

Between the western shore of Lake Aa and Haus Bakenfeld

At a small crossroads not far from Lake Aa starts a little dirt road continuing northwest past a small wooded area through meadows and fields. No signpost indicates either destination or distance. The path leads out of the city into nature. Everyone can take it, wander along or take flight on it. However, when you follow it you will not know where it's taking you. You will wander aimlessly through the day without knowing your destination, without a clue what to expect.

Although we all like shortcuts, Pawel Althamer has gained the impression that hardly any of the inhabitants of Münster leave the routes assigned to them: the pedestrians use the sidewalks and cyclists use the bicycle paths. Pawel Althamer's dirt path could represent a way out of our ordered lives, offering us an alternative, non-prescription, and flexible route.

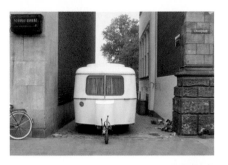

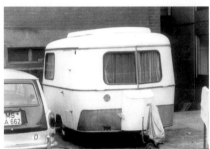

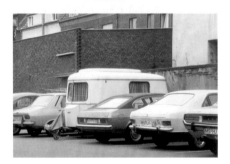

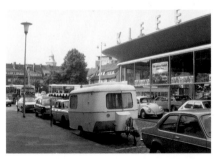

Michael Asher
Installation Münster (Caravan)

A travel trailer is a travel trailer – what else? In Münster, at least, it can become the icon of a major international exhibition. Every ten years during the summer, a seemingly ownerless travel trailer appears on the streets of Münster, standing each week somewhere else. Every Monday, the day when museums are closed to the public, the trailer is relocated. Michael Asher selected the locations back in 1977. In 2007, the American artist will realize his trailer project for the fourth time, making him the only one to have taken part in every edition of the *Skulptur Projekte*.

A member of the Eriba family of trailers, the vehicle may be considered a vintage model today. But over the space of thirty years, this installation has proved to be a simple and impressive long-term study of the city of Münster. As a free-standing sculptural object set in relation to its surroundings, the trailer – which has been documented with photographs since 1977 – reveals the changes that have occurred in the city. Some of the places that still existed in 1977 have disappeared. Indeed, in 2007 the trailer will remain in a garage for five weeks because its former parking spaces are gone. Asher's project, it seems, has a unique seismographic quality.

Nairy Baghramian
Entr'acte

Parking lot at the corner of Wolbecker Str. / Eisenbahnstr.

What is the function of sculptures in public space? Should they have practical use, or should they create distance to the fabric of the city and insist on being autonomous?

The topic does not concern me, you may think. However, the way you answer the question reveals a great deal about how you move about within the city. Nairy Baghramian's sober, minimalist sculpture does not require words, yet it is right at the center of the discussion seemingly agreeing with both propositions – quite an achievement, even for a work of art.

A metal frame, covered with fabric and mirror glass, reminiscent of a paravent, divides the plaza with sophisticated lightness into two spaces, though neither could be described as private, since you are always visible to others. The sculpture almost seems as if it had function – as if it could be used as a screen – but it does not hold up to its promise, at least not immediately. Perhaps the difference created by the paravent will eventually lead to something different happening on the other side. *Entr'acte,* the title of the work, implies a dance-like intermezzo between two partners referring at the same time to the temporary nature of the installation.

Guy Ben-Ner
I'd give it to you if I could, but I borrowed it

19

Tax Office Münster-Außenstadt, Friedrich-Ebert-Str. 46

In the bright, large hall of the tax office in Münster, Ben-Ner has set up three interactive bicycles. The screen between the handlebars shows a film. You can direct the image using the pedals: the faster you pedal, the faster the film in front of you runs. You can also watch the film backwards by pedalling in reverse, allowing you to steer your own enjoyment of art. In the film, the Israeli artist takes his children to a museum, or, more precisely, to an exhibition of readymades – everyday objects that only attain their artistic quality within the context of the museum. There they discover that they can construct an entire bicycle from the exhibits. It is as if the great artists had shared a bike brotherly. Pablo Picasso took the handlebars and saddle for his *Head of a Bull;* Marcel Duchamp took the front wheel and attached it to a chair; Joseph Beuys needed the pump for his *Zerstörte Bat-te-rie;* and Jean Tinguely received the back wheel and the frame for his *Cyclograveur.* Sculptures are destroyed in order to see sculptures: over the course of the intricate plot – which is reminiscent at times of 1920s slapstick – you accompany Guy Ben-Ner and his children on their "stolen" bikes as they ride through Münster from one sculpture to the next, including some of the *skulptur projekte münster 07* exhibits. And you can do this without leaving the tax office – all you have to do is pedal hard.

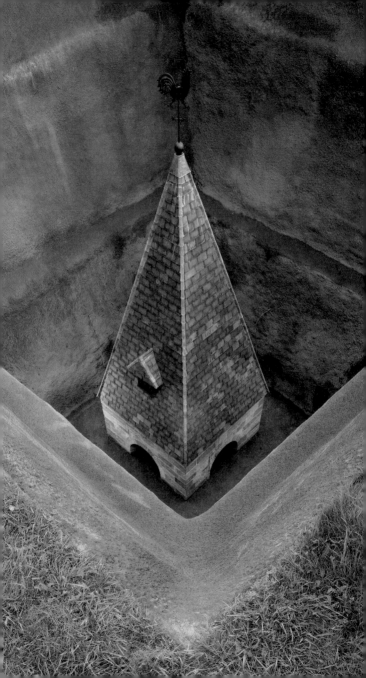

Guillaume Bijl
Archaeological Site (A Sorry Installation)

Sentruper Höhe, near Freilichtmuseum Mühlenhof

You are standing in a grassy area on the Sentruper Höhe by Lake Aa and see nothing but trees and meadows. However, not far in front of you is a milestone of cultural tourism. If you step a bit closer, you can view the archaeological excavation site from a balustrade guarding the edge of the pit. Standing there, you will see an unearthed, shingle-roofed spire topped by a weathercock. Guillaume Bijl discovered it – or rather, the spire is his own invention, as you will quickly have guessed. It is an absurd, surrealist sculpture.

With their steeples, the churches of Münster are still an integral part of the urban landscape. Bijl came up with the idea that "somebody could discover another church – one that had fallen victim to the passage of time, bu-ried during the war." And, thanks to the Belgian artist, Münster has now gained new perspective on the culture of façades.

With his characteristic charm, Guillaume Bijl has added an apologetic gesture to his work, using the name "Sorry Objects" to refer to this and other projects that reveal themselves to be reproductions. However, Bijl is not apologizing for drawing a caricature of our expectations, but rather for betraying his normal emphasis on realism. His modesty will probably not help him much, though, for thanks to you his steeple will become a tourist attraction.

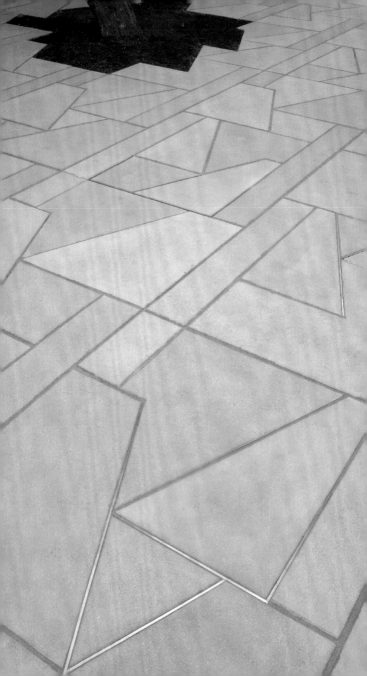

Martin Boyce
We are still and reflective

Himmelreichallee, former zoo grounds

The world comes to life through the attention we focus on it. The cat sitting in the room next door only exists when we go and look at it; what we do not see does not exist for us. And yet it is there, says Martin Boyce – it just needs to be noticed. His work for *skulptur projekte münster 07* does not impose itself on visitors, but takes place horizontally, embedded in the ground on which we move.

The inconspicuous site is covered with formed concrete slabs. Thirteen shapes form a pattern that Martin Boyce has borrowed from the French sculptors Jan and Joel Martel. In the 1920s, these artists designed abstract trees made of concrete, which, according to Boyce, represent "a perfect unity of architecture and nature." Martin Boyce frequently takes up modernist concepts and tests them by delving into the history of design. He confronts what are today regarded as 'classic' motifs by sawing the respective works to pieces or developing them further by making subtle changes.

In selected spaces between the concrete shapes, Boyce has installed bands made of brass that form letters following the outlines of the slabs. The letters say, "We are still and reflective." We are waiting for whatever is coming. Being aware of the sentence embedded in the ground fills this abandoned site with emotion and meaning. It is a silent signal, and though it is transmitted constantly, it does not clamor for our attention, for it has all the time in the world.

Jeremy Deller
Speak to the Earth and it will tell you

Schrebergarten colonies at Mühlenfeld/Lublinring 1 and Martini/Gartenstr. 174

Jeremy Deller focuses on the ego and its interests. When shared by several people interests tend to be organized: in associations, unions, political parties, or perhaps even in amateur acting groups or allotment garden associations. Jeremy Deller does not paint pictures, he stages them. A good example of this is when he commissioned a group of actors to reenact a violent miners' strike in England in a historically accurate fashion – a performance he then captured on video.

His success as an artist is always the success of the people he works with. In Münster he took notice of the phenomenon of the allotment garden associations which must seem rather "German" to a British person. In his project for *skulptur projekte münster 07,* Deller not only concerns himself with the history of allotment gardens as such, but also with all these tales told by their owners: he will distribute a large-format, leather-bound book to each of the fifty-four allotment garden associations in Münster asking their members to use them as a diary over a period of ten years. Deller's interest in people and in various forms of communal life allows viewers easy access to his work.

For visitors to this year's exhibition, Deller also has a souvenir: a little packet, designed by him, containing the seeds of a dove tree. Sow them when you get home and wait for the next *Skulptur Projekte* in the year 2017 – for it will take that long before the dove tree, a broad leaved tree native to China, is in full bloom.

Elmgreen & Dragset
Drama Queens

Project by Elmgreen & Dragset, with text by Tim Etchells
Städtische Bühnen Münster, projection in the foyer of the Westfälisches Landesmuseum

The construction of the Municipal Theater in Münster between 1954 and 1956 marked the end of the conservative reconstruction policy in the city.

In their work for *skulptur projekte münster 07*, the Berlin-based artist duo Michael Elmgreen from Denmark and Ingar Dragset from Norway were inspired by this theater's architecture, which both regard as being visionary, even today. The building provides the setting for their stage piece, a half-hour performance that presents "Superstars from the History of Modern Sculpture." Admittedly, sculptures tend to be static, and hardly anybody thinks there are many parallels between sculpture and theater, but these works actually move – and even speak in the language of their creators. As little psychological dramas unfold on the black, bare stage, it soon becomes clear that these sculpture superstars are fickle creatures. For in a histrionic manner, they act out their primary characteristic – an intrinsic stubbornness.

After the world premiere on June 16 and the documentation of the piece, the theater will be closed for the summer. The video of the performance will be shown in the foyer of the Westfälisches Landesmuseum during the exhibition.

Hans-Peter Feldmann
WC-Anlage am Domplatz
(WC Facilities on the Domplatz)

Domplatz

By the mid-1950s, the reconstruction of Münster's town center had been completed. Around this time, the public toilet facilities at – or, more precisely, under – the Domplatz were also built, with an entrance on the left for "Men" and on the right for "Women." The facilities are used by a large number of people, and not just on the three days of the week that the Domplatz is transformed into an outdoor market. Despite this fact, the public toilets were last renovated in 1987 on the occasion of the Pope's visit to the city.

Today, however, when you go down the steps, you are in for a surprise, for you will encounter neither the unpleasant smell nor the monotonous color scheme so typical of such locations. Hans-Peter Feldmann, a Düsseldorf-based representative of democratic conceptual art, is convinced that public toilets should be well-cared for and pleasant to use. Thus, for *skulptur projekte münster 07*, he has collaborated closely with city officials to have the facilities redesigned to include high-quality ceramics, colorful tiles, and two large-format pictures. And, following Hans-Peter Feldmann's clear idea of what the word "public" should mean, people will be able to use the facilities at no charge.

draußen!

3|2007
€ 1,80

Straßenmagazin für Münster und Umland | 60 Cent für den Verkäufer | www.muenster.org/draussen

The Beggar's Opera
[Die Bettleroper]
Ein Echtzeit-Theaterstück im öffentlichen Raum

Ein Kunstwerk von Dora García
für skulptur projekte münster 07

**mit Samir Kandil, Peter Aers, Jan Mech
und der Stadt Münster**
[nach 'The Beggar's Opera' von John Gay und der Dreigroschenoper von Bertolt Brecht]

Projektförderer: SEACEX (Sociedad Estatal para la Acción Cultural Exterior)

16. Juni - 30. September
www.thebeggarsopera.org

Dora García
The Beggar's Opera

Throughout the city and on the website www.thebeggarsopera.org

Münster has a new citizen. The young man wanders through the city, and he looks like a beggar. But he does not want your sympathy, nor will he ask you for money. He wants your food, your cigarettes – is what you might think. But be careful: the beggar is not what he appears to be. He will tell you stories. Every day, he meanders through the streets and watches you, talks with you – a work of art you need not seek out, because it will find you.

The Spanish artist, Dora García, describes her approach as "a continuous performance in the public sphere." This intrusion puts everyday life in the city during *skulptur projekte münster 07* directly into question, applying the same principle as a Brechtian play: already lying in the gutter, as it were, the supposed beggar has a good view of what is going on around him, and his task in this play – of which the *Skulptur Projekte,* the visitors to the exhibition, and the inhabitants of Münster are part – is to comment on the action. He knows his way around. Ask him, and he will direct you, whether it be to the next sculpture or to the train station. What is really happening on Münster's streets during the exhibition? He will find out and let us know all about his experiences in a daily blog at:

www.thebeggarsopera.org
www.skulptur-projekte.de

Isa Genzken
Untitled

Liebfrauen-Überwasserkirche

On the square in front of the Über-wasserkirche (Unserer Lieben Frauen), a passion play will be performed. As you can see, the contemporary version represents a dramatic departure from the historic original. The new tale of woe does not have to be the same as the one two thousand years ago. Rather than staging sandal-footed figures wearing monk's habits, Isa Genzken presents us with twelve assemblages made up of cheap, garish plastic kitsch, and buried beneath them are the protagonists of the tale – children's dolls – which seem to have gotten tangled up in classical design furniture.

These brash agglomerations of our glitzy consumer world demand our undivided attention. Plastic flowers in shallow seat pans of Plexiglass together with inflatable swim rings and water pistols – it looks improvised, yet it has been composed with great precision. Baseball caps, sunhats, and lots of colorful umbrellas protect the dolls from sun and rain. And they need all the protection they can get, since they are stuck in all sorts of impossible situations, suffering from the neglect that comes with affluence. "Art does not need to be quiet," says Isa Genzken, "but rather an attraction in and of itself." Located in front of a church, the work can certainly be interpreted as a religious statement alluding to the Way of the Cross. But it is the grotesqueness of Genzken's combinations that makes her work accessible to anyone who wishes to comprehend it – be it in silent contemplation or through pure doubt.

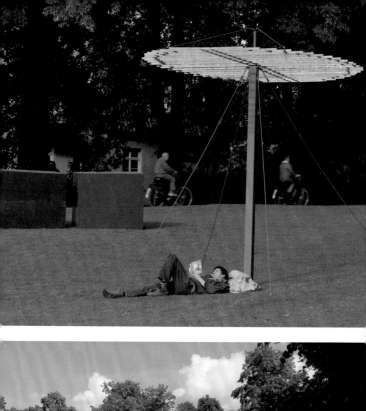

Dominique Gonzalez-Foerster
Roman de Münster (A Münster Novel)

A bank of the promenade, Am Kanonengraben, Aegidiitor

Every ten years, the *Skulptur Projekte* show us a different Münster for 100 days. "A laboratory experiment which, so far, has not produced a theory that could be used for anything," Daniel Buren wrote in his contribution to the 1997 catalogue. But Dominique Gonzalez-Foerster is not looking for the theoretical underpinnings of things. Rather, in her "experiential exhibition" she tells us her version of the history of the *Skulptur Projekte* and their meaning. With its curved slopes, the promenade along the former city wall offers a natural setting for her project.

The artist presents us with a theme park composed of 1:4-scale replicas of selected sculptures from past *Skulptur Projekte* exhibitions — concrete and metal quotations of the original works. Every object is a precise reproduction of the original and is set in relation to the others. Once more we get to see Alighiero e Boetti's *Mann mit dampfendem Kopf* (1997), Ilya Kabakov's *Sendemast* (1997), and Thomas Schütte's *Kirschensäule* (1987), which, even as models, reflect our relationship to the original objects. Dominique Gonzalez-Foerster is not adding any of her own works to the canon. "I'm more interested in articulating differences," says the French artist and curator of this synopsis of past and present attractions.

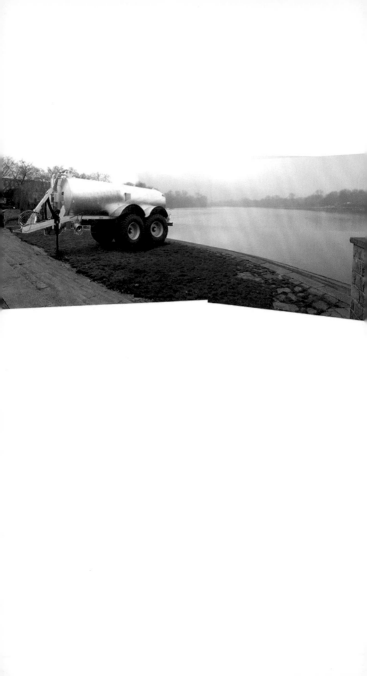

Tue Greenfort
Diffuse Einträge (Diffuse Entries)

Eastern shore of Lake Aa between Adenauerallee and Bismarckallee (half-round platform)

You are neither at Hellbrunn Castle nor at the Wilhelmshöhe in Kassel: what you see in front of you is a fountain on the platform by Lake Aa — a liquid manure truck shooting a jet of water far into the lake. There's nothing negative about the truck's appearance, for when it is illuminated at night, it shines, bright silver, in the light. Perhaps it is only the smell of manure normally associated with this kind of equipment that creates an unpleasant impression. Every citizen of Münster knows this smell, which is hardly surprising considering that almost 15,000 cows and 85,000 pigs are raised in the surrounding Münsterland. However, this particular manure truck is not spraying fertilizer, but rather water taken from Lake Aa and fed with a solution of iron(III) chloride before being pumped back into the lake under great pressure.

A manmade body of water, Lake Aa was created before the First World War as a reservoir for the large amounts of rain that had previously caused annual flooding in the spring and fall. In the 1970s, the lake was expanded to its current dimensions. However, because it is shallow, Lake Aa suffers in particular from the influx of phosphates from fertilizers and liquid manure, which are carried to its waters by various streams and cause recurrent algae blooms. Tue Greenfort sees his work as a critical commentary on the attempts to improve the quality of water in Lake Aa by means of these "inoculations" with iron(III) chloride, since these are little more than cosmetic measures designed to maintain the lake's idyllic — and artificial — image as a local recreational area.

Valérie Jouve
Münsterlands

Pedestrian underpass at Hindenburgplatz

As mobile beings, we experience cities as static. In truth, however, they are made up of many rhythms and present themselves differently depending on the direction we are arriving from and the mode of transportation we have chosen. Valérie Jouve has made a film about how we can approach the city, and she is showing it in a pedestrian underpass – a perfect symbol of life in transit. While the project was being developed, it became clear that the underpass was actually someone's living room. The homeless person who has chosen this corridor as his home is thus given a cameo appearance in the French artist's film.

Her protagonists – French actors of various ethnic backgrounds who at the time had never set foot in Münster – approach the city from its periphery, traveling along the Dortmund-Ems canal on the cargo ship Tahiti, from Amelsbüren to the lock north of Münster and then back south to the Agravis complex. After this, they disembark and continue their journey on bicycles. The camera follows the actors' movements, changing its perspective during the film from one that is ethnologically correct and neutral to one that is subjective and based on the viewpoint of the protagonists. The actors' destination is the place where the projection will be shown – the pedestrian underpass at Hindenburgplatz. The film's soundtrack has a life of its own and is not related to the footage.

Although the tunnel is purely functional in architectural terms, it does have a place in (art) history. In 1977, Joseph Beuys made a wax and tallow cast of the empty space between the pedestrian ramp and underpass, resulting in the wedge-shaped sculpture *Unschlitt/Tallow,* which is now on display in the Hamburger Bahnhof – Museum für Gegenwart in Berlin.

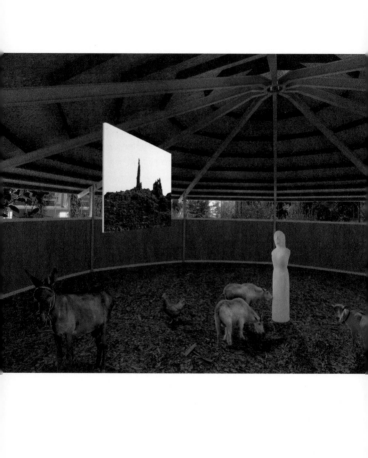

Mike Kelley
Petting Zoo

Inner courtyard at Von-Steuben-Str. 4–6

The angels who came to Sodom and Gomorrah to put an end to the notorious sins of the cities' inhabitants warned only Lot and his wife that they must leave the city. And although they were told to do so without looking back even once, Lot's wife disobeyed the angels' instruction and was transformed into a pillar of salt. However, this sad tale of those who defy a divine decree ends on a conciliatory note in its idyllic final scene: ever since the tragic event, animals have come to the pillar to lick the salt.

Just a stone's throw away from Münster's main train station, the American artist Mike Kelley is restaging this biblical legend, expanding the scene, however, to include you, the visitor. Kelley invites you to visit his petting zoo, which is open every day to the general public. The animals may be fed and petted, and all of them – sheep, goats, and a pony – will be crowding together with you around Mrs. Lot's pillar, which Mike Kelley has fashioned according to images from children's bibles from his own boyhood.

Studies have demonstrated that petting animals relieves stress and may even promote longevity in humans. However, affection also leads to feelings of dependence, and in one's desire to do only the best for oneself and others, love proves itself to be blind. Strangely enough, the animals in Kelley's petting zoo are shown videos of 'Lot's Wife' on three screens – only here we do not see a woman, but three rock formations named after her: one on the Dead Sea, the other in New South Wales, Australia, and the third on the island of Saint Helena.

Suchan Kinoshita
Chinese Whispers

21

Handwerkskammer / Chamber of Crafts Showroom,
entry above the parking lot Bismarckallee 1

Between me and you is the "and" — it is spoken language that connects us to one other. And it is also words that separate us — if the "and," for instance, were suddenly to disappear. "Chinese whispers", known in German as "Stille Post" [silent mail] and in French as "téléphone arabe" [Arabian telephone], is a kindergarten game that illustrates our dependence on language more clearly than any linguistic theory. Someone whispers something into your ear, and you convey what you have understood to the next person, and so on until — at the end of a long row of people — we hear something that, thanks to misunderstandings and misinterpretations, no longer resembles the original message.

In her project for *skulptur projekte münster 07,* Suchan Kinoshita reenacts this childhood game, selecting sentences from illustrated magazines and the writings of various philosophers and language theorists, and asking speakers commissioned by her to invent their own sentences, as well. Other participants include so-called "disrupters," who deliberately alter the phrases by translating them into other languages. With sensitive recording techniques, Kinoshita eavesdrops on these "Chinese Whispers," powerfully illustrating how the spoken word is subject to continuous change. In the Münster Chamber of Commerce, visitors can hear the resulting sound loop twenty-four hours a day without interruption. The large window in the showroom provides a full view of the street outside, which will almost automatically become the focus of the listener's gaze. But standing in this open space, our ears entranced by "Chinese Whispers," we will have the chance to reflect on Wilhelm von Humboldt's assertion that there is no escape from the circle drawn around us by our language.

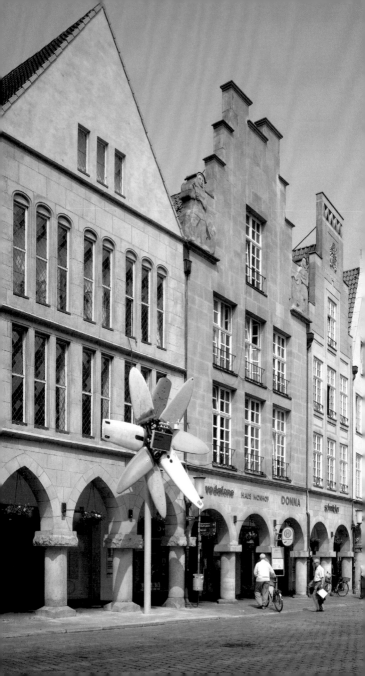

Marko Lehanka
Blume für Münster (Flower for Münster) 08

Prinzipalmarkt 41

There is something soothing about looking at flowers, writes Sigmund Freud; they known neither emotions nor conflict. Münster's venerable Prinzipalmarkt, however, is currently home to a flower that, high up on a pole, has petals made of surfboards cut in half and tells muddled stories — all of which end in death.

The center of the blossom is occupied by a monitor and speaker connected to a computer. Marko Lehanka has developed a software program that generates stories set in Münster and starring the city's inhabitants as protagonists. First names, family names, and street names from the city's telephone book are fed into the computer, and a weather station provides meteorological data that are incorporated in each tale. In this work, as in his entire œuvre, Lehanka uses the local as his model for the global — "I also live in Münster — but in Butzbach-Münster."

The conclusion of the stories is predetermined: they all end with the death of the characters. However, we should not hold this against the flower, with its black, cold heart, since killing off the characters is the most logical way for the computer to finish one tale and move on to the next. The speaker may laconically stammer out one death after another, but considering the constant stream of information to which we are subjected in everyday urban life, the flower's muddled talk makes more sense than we might think upon first hearing — and testifies to the subtle humor of the artist and programmer Marko Lehanka.

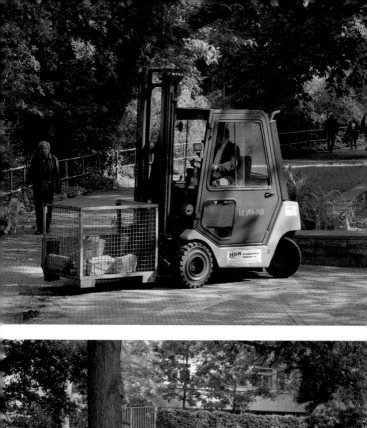

Gustav Metzger
Aequivalenz – Shattered Stones

Please refer to the internet site www.aequivalenz.com, Westfälischer Kunstverein in the Westfälisches Landesmuseum

Forty years ago, Gustav Metzger already had such a radical view of art that he demanded that people boycott his own creations – and for the next four decades he was entirely ignored by the art establishment. However, Metzger influenced people nonetheless. His auto-destructive art, for instance, inspired Pete Townshend from The Who to destroy his guitars, and his liquid crystals set on wafer-thin glass, which illustrate Metzger's notion of auto-creative art, became an important feature in The Cream's psychedelic stage shows.

For *skulptur projekte münster 07*, the London-based artist has created a work that manifests itself fleetingly in the form of transient actions. By presenting us with a machine and adding the factor of randomness, Gustav Metzger is promoting "a radical extension of accepted unproductive notions of art."

Every day during *skulptur projekte münster 07* – that is on 107 occasions – a man will drive a forklift to the Westfälischer Kunstverein, step off the vehicle, go inside the building, and use a password to activate a computer program that will inform him, by means of a random generator, how many stones he has to take to a certain location in the city. The man will find his payload in the courtyard of the Landesmuseum, use the forklift to take it to the allotted place, and then make a photograph of the pile of stones. When he returns to the Kunstverein, he will post the image online for all to see.
www.aequivalenz.com

Eva Meyer & Eran Schaerf
Sie könnte zu Ihnen gehören (She Could Belong to You)

Mauritzhof Hotel, Conference room, Eisenbahnstr. 17

"It could belong to you," the city of Münster – does that sound like a threat or a friendly offer? Eva Meyer and Eran Schaerf will not say. But you have the choice. She is a Freiburg-based philosopher; he is an artist from Tel Aviv. Together, the couple have set up camp in the Mauritzhof Hotel, and they will show you Münster from an unusual perspective – not as it appears in front of your eyes, but the way the camera sees it. As Eran Schaerf notes, "We will approach Münster as if it were a film, and we will approach the film as though it were Münster."

The town becomes a cinematic sculpture in which the artists create yet another film by using a montage of three films that were shot, or set, in Münster. The three films are *Alle Jahre Wieder* [Next Year, Same Time] by Ulrich Schamoni, shot in December 1966, *Desperate Journey* by Raoul Walsh, filmed in 1941/42 in Hollywood, and the documentary *Zwischen Hoffen und Bangen* [Between Hope and Fear], made from private footage of the Jewish family Gumprich from Münster, filmed between 1937 and 1939.

The montage of scenes from these films and footage they shot themselves creates a new cinematic dimension – a cinematic Münster in which the boundaries between fiction and documentary dissolve and each viewer can create his or her own Münster.

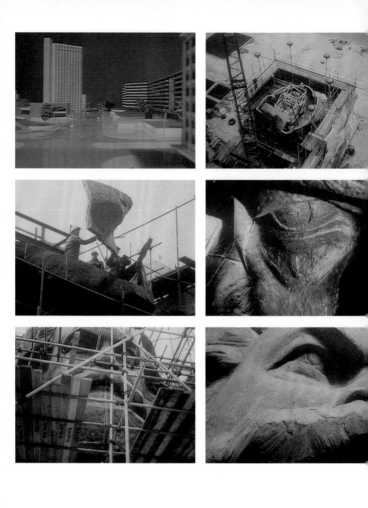

Deimantas Narkevičius
The Head

Atrium of the LWL-Landeshaus, Freiherr-vom-Stein-Platz 1

Deimantas Narkevičius was studying sculpture in Vilnius in the early 1990s when the fall of the iron curtain put an end to the genre of socialist realism in Lithuania. Within just a few days, almost all of the monuments from the Soviet era had been removed from the city. In *Once in the XX Century,* Narkevičius uses a simple montage technique to comment on this iconoclasm. By playing images in reverse motion, he shows a statue of Lenin not being removed, but erected to the audience's applause. As Narkevičius points out: "Everyone seemed to think that removing these objects would lead to immediate changes in society." In truth, however, the people had simply disposed of silent witnesses to history.

Some of these witnesses have survived, including the gigantic bust of Marx in Chemnitz. When Lew Kerbel was commissioned to create a monumental sculpture of Karl Marx for a parade ground there, he surprised everyone with a design for an enormous bronze bust on a plinth: "Karl Marx has no need for legs or hands; his head says everything." Seven meters high, seven meters wide, and nine meters deep, the philosopher's bust weighs a full forty tons. When it was unveiled in 1971, a quarter of a million people were in attendance to celebrate the occasion. A film by Narkevičius presents people's reactions to the monument, both then and now.

Narkevičius' original idea would have explored the extent to which society has changed since then, both in the East and in the West. He had proposed removing the bust in Chemnitz and transporting it to Münster, where it would have been displayed for the duration of *skulptur projekte münster 07* before being returned home. Unfortunately, this project proved impossible to realize. Marx in Münster remains an idea but one that captures our imagination.

Election rally with Erich Honecker, June 1981, Source: Stadtarchiv Chemnitz

Bruce Nauman
Square Depression

Naturwissenschaftliches Zentrum / Center for Natural Sciences, Wilhelm-Klemm-Str.

In 1977, Klaus Bußmann from the Westfälisches Landesmuseum had the idea for a sculpture exhibition; Kasper König invited nine artists to realize projects outdoors, thus taking art out of the museum and installing it in urban space. Bruce Nauman planned an outdoor sculpture for the campus of the university's department of natural sciences: a walk-in object made of white concrete, its edges extending downwards and crossing at the lowest point in the center, from where an observer could almost glance over the sides. Finally realized for *skulptur projekte münster 07,* Nauman's sculpture is the inverted pyramid you now see before you.

Square Depression is literally a square let into the ground, but — then as now — Bruce Nauman's title for the work is a play on the word "depression." Depressive, helpless, to be at someone's mercy is how you feel when you stand at the center of this sculpture. It is about the formal qualities of space and the vanishing point; at the same time *Square Depression* represents the spatial construction of a psychological state below the level of the vanishing point. As a sculpture, Nauman's work shows us just how much perspective can be regarded as constraint — and to what extent it can actually inflict violence. *Square Depression* is a staged threat, which now — upon its completion in the year 2007, thirty years after it was originally planned — is as haunting and topical as ever.

Maria Pask
Beautiful City

At the Palace moat near Einsteinstr. (close to *Three VOID Stones* by George Brecht and *Sanctuarium* by Herman de Vries); www.beautifulcity.de

Towards the end of the 1960s, when industrial societies were prospering like they never had done before, the so called '68ers movement,' and the hippies in particular, rebelled against established society. In search for alternative lifestyles and values, some of them turned to exotic religions and other forms of 'spirituality.'

Maria Pask was two years old when the musical *Godspell* first came to the stage with its song of a 'beautiful city' built not of stones, but spiritual visions. This summer during *skulptur projekte münster 07,* a similarly 'beautiful city' – of tents – will arise on a meadow to the north of the Schlossgarten. The Dutch artist has invited representatives of a wide variety of religions and persuasions to Münster; each weekend, within a white tent, a different speaker will present his or her religious or spiritual convictions to the public. As an independent theologian from Münster notes, "You don't have to be religious just because I am";

a witch from Dortmund insists that she "doesn't give counseling by phone"; and a Buddhist will explain why Buddhists do not "believe." All of them will address topics that the artist has put up for discussion. An important aspect will be the question of whether and how different religious beliefs, all with their own claims to interpretative authority and truth, can be reconciled with one another.

Followers, friends, and the general public are all invited to camp here during the week in the vicinity of Herman de Vries' *Sanctuarium* and George Brecht's *Three VOID Stones* – two works from earlier editions of *Skulptur Projekte* in Münster.

Maria Pask's *Beautiful City* explores the potential of different forms of faith in the context of art and modernity.

We will see, if faith and tolerance are consistant, and if art can thus provide the setting for such a debate.

www.beautifulcity.de

D&F.Anlage-Y.E.S(Ö)

Denkmal & Freizeitanlage – York, Engelen, Schmitz
(Übergangswohnheim Lankenau)

Manfred Pernice
D&F.Anlage-Y.E.S(Ü)

At the corner of the Engelenschanze / Windthorststr.

The materials he uses tell stories: the wood comes from various building sites, and this or that doorframe has been in someone's living room for years. Even as part of a self-contained sculpture, the prior life of the materials shines through. In this way, by compressing and layering elements, Manfred Pernice creates relationships between spaces. Indeed, Pernice treats the location of his work just as freely as he juxtaposes various architectures within them. On the lawn of the Engelenschanze, which is in the heart of downtown Münster on the way to the main train station, Manfred Pernice will create a 'Memorial & Recreational Facility.' Once the stone benches have disappeared underneath a concrete slab, Pernice will install a steel pavilion with a glass roof upon this newly created platform. The Berlin artist has brought the pavilion with him to Münster from the district of Hohenschönhausen in the east of Berlin. Next to it he has erected a column modeled after the *Schmitz-Säule* in the old part of Cologne, which documents the exact distance to the moon and was unveiled at the very moment Neil Armstrong set his foot on the lunar surface. Pernice's work, however, is inscribed with information pertaining to Münster. A new position-fixing, bearing will be taken for the column, here at the Engelenschanze – a place that has undergone many changes over the course of history: once a bastion, then the domicile of Johann Engelen, and afterwards, following its destruction during the Second World War, a small park that eventually became home to George Rickey's kinetic sculpture, the first modern outdoor sculpture in the city (1973). Many of Münster's citizens objected to it when it was purchased in 1975, but we now know that it provided stimulus for the first edition of the *Skulptur Projekte* in 1977.

Susan Philipsz
The Lost Reflection

Under the Torminbrücke / Lake Aa

An aria sounding from under the Torminbrücke at Lake Aa: Susan Philipsz sings "Lovely night, oh night of love, smile upon our joys!", the barcarole from Jacques Offenbach's *The Tales of Hoffmann.* The score is based on *The Story of the Lost Reflection* by the German romantic writer E.T.A. Hoffmann. It is the story of the seductive yet unfortunately vicious charm of the courtesan Giulietta, whose spell men cannot resist, thereby losing their own reflection, so that neither their wives nor their children are able to recognize them.

The story is set in Venice, and when Susan Philipsz's amplified voice resounds across Lake Aa and back again, the lagoon city with its many canals which inspired the artist in choosing the song is evoked.

The human voice is unable to change the space it fills, but it completely alters our experience of that space. Standing under the Torminbrücke at Lake Aa, we are swept away to the balcony of a palace on the Canale Grande as we listen to Giulietta and Niklaus intone: "Time flies by, and carries away our tender caresses for ever! Time flies far from this happy oasis and does not return." Susan Philipsz sings both voices recorded on two separate tracks, and it almost seems as if the voices were calling to each other across the lake and back joining only to lose each other once more, not in the splashing water, but in the rushing noise of the traffic. The singer, too, has vanished — only her voice is lingering.

Martha Rosler
Unsettling the Fragments

Plaza in front of the Municipal Library (Stadtbücherei), church square, at the choir of St. Lamberti, corner of Rothenburg / Königsstr.

History is painful — a fact that even the most carefully crafted monument cannot convey. Our desire to put memories of suffering behind us often lead to attempts to cover up or eliminate the traces of the past from the urban landscape. However, Martha Rosler asks why history must be portrayed as seamless, for is it not the contradictions that ensure that an urban community remains vital?

In an effort to expand our perspectives, the American conceptual artist has transformed Münster into a kind of memory game, creating an interplay of architectural symbols. We, the visitors to the exhibition, are to uncover an image and then find its counterpart.

The emblem of an eagle that adorned the former Luftgaukommando built by Ernst Sagebiel in 1935 for the Wehrmacht (today the Air Transport Command of the German Armed Forces) on Manfred-von-Richthofen-Straße — is also affixed to a pole in front of the Münster arcades, a shopping complex designed by Josef Paul Kleihues. The original cages that were used to display the corpses of leading Anabaptists after their torture and execution in 1536 hang from the tower of St. Lambert's Church; their replicas are suspended from the façade of the municipal library. In turn, the Botanical Garden is home to a bamboo arcade whose counterpart leads from the choir of St. Lambert's Church to the municipal library. From military to commerce to church to culture and to knowledge — with their architectural fragments, all of these institutions contribute to the urban landscape we see today.

Because the different parts of her project are located throughout Münster, Martha Rosler has hung information boards on the façade of the municipal library, including an index of all exhibits and their locations. Together, these represent Rosler's reading of the city.

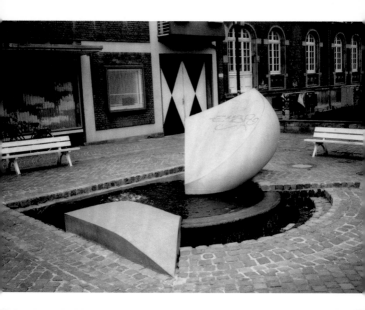

Kunst wird überdacht

„Skulptur-Projekte 2007": Die ersten Künstler radeln suchend durch die Stadt

Für die Skulptur-Projekte 2007 plant der Künstler Thomas Schütte in unmittelbarer Nachbarschaft der Kirschens „Kunsthalle" für den anonymen Wulst-Brunnen. Foto: Me

Von Gerhard H. Kock

Münster. Thomas Schütte kennt den Künstler nicht,

uns nächste Jahr. Projektleiterin Dr. Christine Lutz: „Die Künstler erfahren sich zur Zeit die Stadt mit dem Fahr-

gestalten und die Kosten-ifiich abschaffen.

Nach 30 Jahren wird eine Arbeit von Bruce Naumann rea-

lich politisch deni Wagner. Sie will für ein Arbeit von Hanne chir der sozialen Brei

Thomas Schütte
Modell für ein Museum
(Model for a Museum)

14

Harsewinkelplatz

Thomas Schütte returns to Harsewinkelplatz, where in 1987 he erected his *Kirschensäule.* This ironic-critical commentary on Münster's architecture became one of the city's landmarks and gave reason for the plaza's redevelopment. Back then, the artist refused to consent to the pillar's relocation. Nevertheless, the parking lot became part of a pedestrian zone where the Chamber of Commerce erected a fountain. For *skulptur projekte münster 07,* Schütte has covered the fountain with a glass construction which does not hide what it covers, serving at the same time as a base for *Modell für ein Museum* which stands in radical contradiction to the clustered architecture of the surrounding plaza.

Will the model actually be realized one day? Thomas Schütte lets his models be what they are, regardless how large they turn out to be. Already in 1981 he developed *Modell für ein Museum* for the first time, albeit on a much smaller scale. The deception: Although it confronts us with impressive dimensions, the viewer still ponders what it would be like if the model was actually built – a work that invites viewers to play with the possibility.

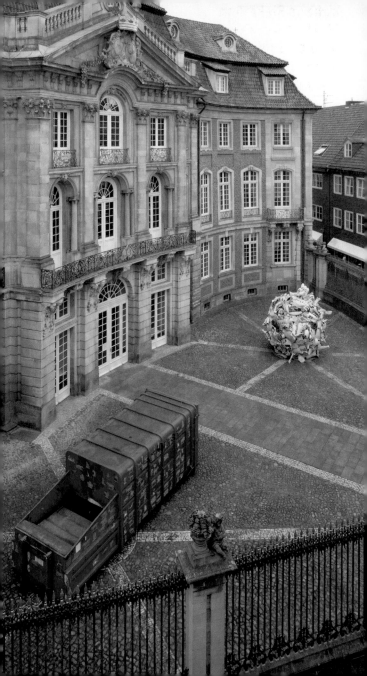

Andreas Siekmann
Trickle down. Der öffentliche Raum im Zeitalter seiner Privatisierung (Trickle down. Public Space in the Era of Its Privatization)

Erbdrostenhof, Salzstr. 38

The most beautiful corner of Münster is round – or so goes the saying by which locals mean the Erbdrostenhof, a noble's palace built in the baroque style by the architect Johann Conrad Schlaun. Here, where Richard Serra placed twenty-four tons of steel in 1987, Andreas Siekmann has found the ideal stage for his protest sculpture. As we can see from the subtitle of the work – *Public Space in the Era of Its Privatization* – this is no short story.

Since 1998, town centers in Germany have been invaded by an army of plastic figures, mostly in the shape of animals and referred to as "urban art" by city marketing departments. Now present in 600 cities and municipalities in Germany, these plastic figures are supposed to serve as distinctive landmarks in each town. But in truth they are the mute witnesses of a broad economic transformation, as part of which many areas of public life have been sold to private investors. Indeed, urban space has been put up for sale.

For *skulptur projekte münster 07,* Siekmann has taken thirteen of these figures, put them in a compactor, and used the resulting debris to create a large sphere, which he is placing, along with the compactor itself, in front of the Erbdrostenhof.

It is biting commentary on the "trickle down" theory of Adam Smith, which holds that great wealth, even if it is concentrated in the hands of a few, can trickle down to lower segments of society, bringing prosperity to all. Translating abstract economic processes into simple pictures is almost impossible, but Siekmann successfully does so with his typified visual language, similar to pictograms. With these images, which cover both the compactor and form a frieze that adorns the inner courtyard, the artist summons the global economic players to the court of art. This work, and Siekmann's œuvre as a whole, depict power relations that are seldom put on display.

Rosemarie Trockel
Less Sauvage than Others

Lake Aa, near the Torminbrücke

Rosemarie Trockel is bold in matter, mild in manner. With forceful precision, she places her sculpture, made of yew bushes, near Donald Judd's work on the shore of Lake Aa, gently combining nature with nature by placing two blocks of the evergreen tree onto the meadow.

Taxus baccata, the common yew, grows slowly, even in shadowy spots, and can live to be as old as a thousand years (some are said to be over two thousand years old). In the Middle Ages, the finest bows were made of its wood, but since yews are mostly poisonous for humans and for many animals, efforts were made to prevent their spread. Today, an anti-cancer drug is extracted from its bark.

Like green monoliths they stand next to each other — seven meters long, three and a half meters deep, and four meters high — slightly staggered and neatly trimmed to look like sculptures made of wood and stone, forming a narrowing gap through which we can see the shimmering waters of Lake Aa and a high-rise block on the shore beyond. Is it an attempt to create an English landscaped garden, with a window-like perspective of a special building — or just an autonomous sculpture in and of itself?

Less Sauvage than Others is what Rosemarie Trockel calls her installation. The precision trimming means it will not grow wild, and both blocks will remain in place after the exhibition.

Silke Wagner
Münsters Geschichte von unten
(The History of Münster from Below)

in front of the Stadthaus 1, Klemensstr. 10

When Paul Wulf was seven, he was put into a home because his parents' apartment was too small for a family with four children. In 1932, he was moved to an asylum for the mentally ill. When his parents wanted to take him back, he was declared mentally retarded, and, in March of 1938, he was sterilized against his will in the Paderborn State Hospital. It was the day after the Germans had annexed Austria. As Wulf himself described, "While everyone was shouting 'Sieg Heil, Sieg Heil,' the annihilating knife was plunged into my body." Paul Wulf was sixteen at the time. He was to live another sixty years. Since 1949, he fought legal battles against the Federal Republic of Germany, but to no avail. While he was still alive, Paul Wulf, who despite his height walked with a stoop and appeared to be slight of build, could be seen on the streets of Münster carrying a heavy black briefcase filled with files and newspaper articles – documents pertaining to his struggles against fascism. He was a collec-tor of stories that people would rather forget; he would randomly confront passers-by with the do-cuments he carried in his brief-case and ask them questions they would never have asked themselves.

Now, here he stands, 3.5 meters tall, as a memorial in front of the Stadthaus – a sculpture that also serves as an information column. It is as though the contents of his briefcase had spilled out onto his coat, creating a documentation of Münster from below – a chronicle of political events, of housing struggles, or of the anti-nuclear movement. With her project, for which the artist has collaborated with the Umweltzentrum-Archiv Münster [Environment Archive Society], Silke Wagner has es-tablished a public forum for com-plex issues. The information co-lumn is only one part of the pro-ject; the archive is also being digi-talized, and a website is under construction.

www.uwz-archiv.de

Mark Wallinger
Zone

Traffic island Aegidiistr. / Rothenburg, various places in the town center

Here on this unspectacular traffic island in front of the Aegidiimarkt you are in the middle of things – at the center of a circle that surrounds most of the inner part of the city. Mark Wallinger has installed a five-kilometer-long rope that reaches a height of four and a half meters at Münster's greatest elevation, even extending to fifteen meters over Lake Aa – high enough for sailing boats to pass underneath with their long masts.

A sculpture in the sky: the circle cuts through houses and bores its way through façades of buildings. Like many boundaries, Wallinger's circle is not recognizable as such. You see it only if you look for the markings. But walking through town, you will cross the rope many times and notice it only if you look upwards towards 'higher things.' However, precisely this is the British sculptor's intention.

The Talmud calls it "Eruv," an area precisely defined by customary rules within which some of the thirty-nine prohibitions by which orthodox Jews must abide during the Sabbath do not apply. Thus, the zone created by Mark Wallinger also represents a transcendent demarcation, just as for centuries the walls of monasteries separated the sacred from the secular. Without you even noticing it, the circle draws you in, and as long as you are moving about within its boundaries, you are part of the community.

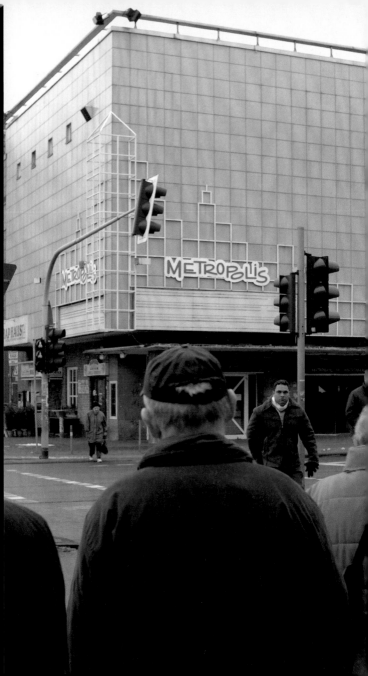

Clemens von Wedemeyer
Von Gegenüber
(From the Opposite Side)

Metropolis Cinema, Berliner Platz 39

Do you like Russian matryoshka dolls, and are you pleased when the doll inside the doll looks exactly like the one before? It's a nice thing, that faint sense of giddiness we feel when the new is the old, when the front is the same as the back, again and again – space that does not contain anything except one cover after the other.

The old Metropolis Cinema on Berliner Platz is nothing more than a façade. It has been standing empty for eight years – the seats have been sold, the screen has yellowed. The exception – a cinema not showing any films – has become the rule, creating a kind of in-between space that Clemens von Wedemeyer knows how to exploit, to reflect the conditions of the cinema. Inside, in the dark auditorium, his film is running as an infinite loop, showing the outside, the area around the train station, the immediate surroundings of the cinema. Clemens von Wedemeyer combines documentary footage, shot with a hidden camera, with staged material. Actors play passers-by, and passers-by thus become actors. A film without a plot, it is a silent observer.

The station is like the cinema: it offers lonely people the chance to feel they belong. "This is where people congregate who don't otherwise know where they belong – or who haven't yet found their place in this city." Clemens von Wedemeyer lets these people on the margins express themselves, silently.

The cinema is also an information point for *skulptur projekte münster 07* and a venue for numerous events from the supporting program (see program guide).

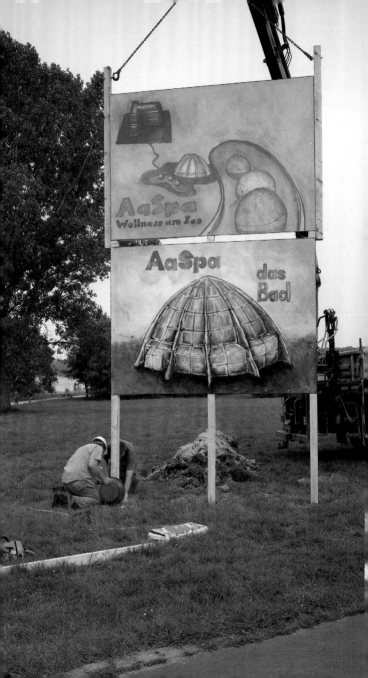

Annette Wehrmann
Aaspa – Wellness am See
(Aaspa – Rest & Relaxation at the Lake)

25

Lake Aa, south of the Freilichtmuseum Mühlenhof

"Anyone who has gone swimming on a warm summer's day only to emerge from the water not like a snow-white swan, but covered in mud […] will rejoice at the sight of the new municipal swimming baths opened to the public this morning," wrote the Münsterischer Anzeiger on June 11 1888. Now, well over a century later, aquatic pleasures are still all the rage. A center dedicated to fitness and well-being will soon be built at this prime location on the shores of Lake Aa. The construction site has been prepared, containers and distribution boxes are in place, and the trees have been wrapped in plastic sheets to prevent damage from construction vehicles. The sign posted at the site shows us how the building will eventually look – a dome-shaped, perfectly round glass structure, supported by struts. In bright red letters, it reads "Aaspa – Rest & Relaxation at the Lake".

AaFit+Well, Ltd. is building a spa hotel at this very spot, and what you see is the first stage in its construction. Once completed, the complex will cover most of the surrounding meadows. Already, a hoarding is blocking a sizeable part of Münster's local recreational area – a no-go zone created by the artist Annette Wehrmann. During the exhibition, the building site will change and grow – the work is beginning.

Whether this paradisiacal spa center will really be built is something we will not learn until the end of the season. Perhaps the construction site will disappear along with the summer, leaving nothing behind – except, perhaps, a bit of a shock.

Pae White
my-fi

Alter Steinweg 3/4, Rothenburg 13, Stadthausturm at the Prinzipalmarkt,
Café Kleimann at Prinzipalmarkt 48

In the historic city center of Münster, Pae White creates a romantic connection between Westphalia and California, where the artist lives. Münster's old town becomes a part of the Camino Real – the "Royal Road" linking the former Spanish missions in California.

Three carillons play the artist's favorite love songs, such as *Girl, You'll be a Woman Soon* by Neil Diamond. The melodies mark the tourist route, one carillon hanging over Wilhelm Nonhoff's World Clock on the building at Rothenburg 13, another on the Stadthausturm, and the third at Lambertikirchplatz (Alter Steinweg 3/4). Pae White's aesthetics are akin to a friendly embrace. She encloses spaces by giving them a soundtrack made up of her favorite songs, her first love songs. Two large bells, similar to those on the Camino Real, stand by the wayside. These also bear traces of Pae White's influence, for they look oddly squashed, as if someone had given them a mighty hug.

Indeed, Pae White's affection impresses itself upon things, remodeling them. For the exhibition in Münster, she has also mixed Californian fast-food culture with the art of traditional confectionary making, presenting miniature marzipan sculptures of so-called "taco trucks" in the window of Café Kleinmann at Prinzipalmarkt 48 – the last remaining building in the old Münster style, erected in 1627. The confectioners there were commissioned by the artist to create replicas of these mobile restaurants, which park along the streets of Los Angeles and sell tacos around the clock.

77/87/97/07 archive
Temporary architecture switch+
Visual concept

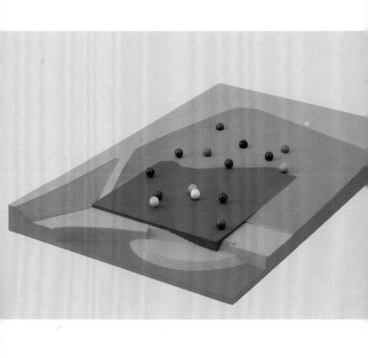

77/87/97/07 archive

Atrium of the Westfälisches Landesmuseum für Kunst und Kulturgeschichte,
Domplatz 10

From the very beginning, the planning and organization of *Skulptur Projekte Münster* has been in the hands of the Westfälisches Landesmuseum in Münster. Thanks to the exhibitions, the museum and the city of Münster has become the proud owner not only of thirty-nine important international outdoor sculptures, which are permanently presented in the urban space or in the museum. The museum also houses a substantial but up until now little known collection of preliminary artistic materials, including models, blueprints, design drawings, correspondence, and commentaries as well as a collection focus in the museum's library.

The exhibition *77/87/97/07 archive* accompanies *skulptur projekte münster 07*, this exciting and one-of-a-kind collection will be open to the public for the first time.

The archive exhibition will be displaying models of realized projects — including Claes Oldenburg's *Poolballs* (1977), Richard Tuttle's work *Untitled* (1986) or Rosemarie Trockel's *Less Sauvage than Others* (2007) – as well as models of unrealized works by artists such as Katharina Fritsch or Olaf Metzel (both 1987). The design drawings and correspondence provide important background information on artistic decisions and the approaches taken to public and visual cultures and the question of sculptural form. Selected newspaper articles document the vivid, occasionally controversial public debates triggered by each edition of the *Skulptur Projekte* to date.

This extensive collection represents an invaluable and art historically outstanding resource, documenting the creative process and the individual artist's approaches to the topics of "urban space," "art in public places," and "outdoor sculptures" of the past thirty years as well as its reception. *77/87/97/07 archive* was conceptualized and organized by Brigitte Franzen.

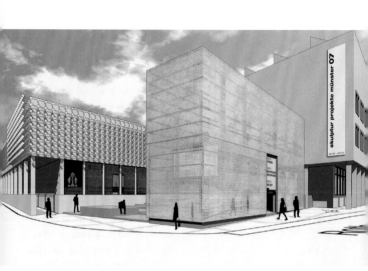

Temporary architecture switch+

modulorbeat – Marc Günnewig and Jan Kampshoff, Rothenburg 30

For *skulptur projekte münster 07*, a temporary structure has been created for the plaza in front of the former Westphalian Museum of Archeology at Rothenburg 30. Designed by the Münster-based architecture firm modulorbeat, an approximately twelve-meter-tall pavilion called switch+ offers a central location for services related to the exhibition, including an information point, catalogue sales, rentals of the multimedia tour system, and a specialty bookshop.

The structure has produced an entirely new environment between the existing building at the corner of An der Rothenburg and Pferdegasse. What previously was an open and unused space has become an ideal meeting place. To enliven the plaza yet further, a café has been opened up in the foyer of the *Skulptur Projekte* office, with outdoor seating extending to parts of the plaza and pavilion.

Situated in the area leading up to the office entrance, the pavilion forms what one could call an "urban switch": part of the pavilion is moveable and can be used to shift the flow of pedestrians on the plaza – and thus alter their use and perception of public space. For the pavilion's outer shell, modulorbeat architects Jan Kampshoff and Marc Günnewig chose a gold-colored casing made of perforated copper sheets.

The pavilion alludes in many ways to its immediate surroundings. The golden outer shell is a response to Otto Piene's *Silberne Frequenz* (*Silver Frequency*), a relief on the façade of the Westfälisches Landesmuseum. Another source of inspiration was the golden lettering that designer Martin Schmidl developed as a trademark for *skulptur projekte münster 07*, and which can also be seen on museum façade.

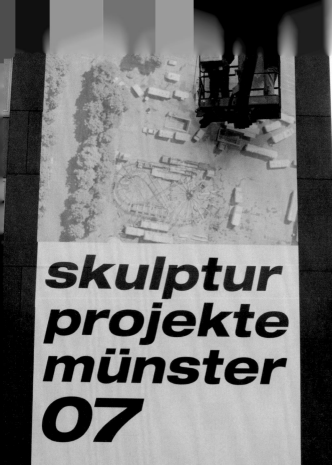

skulptur projekte münster 07

17.6.–30.9.

Visual concept

Martin Schmidl

The visual identity of *skulptur projekte münster 07* is clear and to the point. It thus lives up to the conviction that the purpose of art is not to brighten up or decorate urban space, but rather to reflect critically on the tendency to use art as a decorative instrument. The typeface for this year's exhibition was chosen by the exhibition's curators, Brigitte Franzen, Kasper König and Carina Plath, back in the summer of 2005. It was designed by the artist Martin Schmidl.

The exhibition logo for *skulptur projekte münster 07*, a line of text about fifteen meters in length, has been installed on the building in which the project office is located, above a row of windows and on the left-hand side of the façade. Seen as a sculpture, this installation explores issues surrounding marketing and public presentation. To achieve this, the lettering has been transferred to a weatherproof surface using gold-colored foil. The color is a reference to the gold lettering – chosen out of marketing considerations to create a sense of luxury and value – on the many shop fronts between Prinzipalmarkt and Aegidimarkt. This approach is not unique to Münster, but in this location it is particularly apparent and has the function of a public statement. Thus, Martin Schmidl's work addresses questions about art's purpose or lack of purpose in the public sphere. What does it mean when the logo of an art project appears in the same guise as the lettering above an expensive clothing boutique? And what happens, in this context, when visitors look more closely and realize that the exclusive gold of the lettering is nothing but cheap foil?

Especially from the perspective of the larger national and international audience, major art projects like these are expected to innovate. And because it is internationally renowned, *Skulptur Projekte Münster* has to prove time and again that it will not rest on its (golden) laurels.

Imprint

© 2007 *skulptur projekte münster 07* / LWL-Landesmuseum für Kunst und Kulturgeschichte, Münster, Director: Hermann Arnhold, Artists, Author and Verlag der Buchhandlung Walther König, Köln

Editors
skulptur projekte münster 07 / LWL-Landesmuseum für Kunst und Kulturgeschichte, Münster

Author
Frank Frangenberg

Editorial Responsibility
Annkatrin Gründer
Birgit Nienhaus

Translation
Matthew Gaskins

Copyediting
Uta Hoffmann

Proof Corrections
Michael Ammann
Birgit Nienhaus

Visual Concept
Martin Schmidl

Layout Team
Linda Kasprowiak, Malte Rommel
Christina Tensing

Typesetting
Daniela Löbbert

Photography
Thorsten Arendt/artdoc
Roman Mensing/artdoc

Published by
Verlag der Buchhandlung
Walther König, Köln
Ehrenstr. 4, 50672 Köln
Tel. +49 (0) 221 / 20 59 6-53
Fax +49 (0) 221 / 20 59 6-60
Email: verlag@buchhandlung-walther-koenig.de

Die Deutsche Bibliothek – CIP-Einheitsaufnahme
Ein Titelsatz für diese Publikation ist bei Der Deutschen Bibliothek erhältlich

Production
Printmanagement Plitt,
Oberhausen

Printed in Italy

ISBN: 978-3-86560-281-7

skulptur projekte münster 07
17.06.07–30.09.07

Curators
Brigitte Franzen, Kasper König
In Cooperation with
Carina Plath,
Westfälischer Kunstverein

Project Manager
Christine Litz

Institutions of the exhibition
Major Sponsors/Project Sponsors
Informations on the exhibition

skulptur projekte münster 07
LWL-Landesmuseum für Kunst
und Kulturgeschichte
Domplatz 10, D-48143 Münster
Tel.: +49 (0)251/5907-201
Fax: +49 (0)251/5907-104
besucherbuero@
skulptur-projekte.de
Monday to Friday: 9–18 h

Cooperative project of
Landschaftsverband Westfalen-
Lippe (LWL), the city of Münster
and the state of North-Rhine
Westphalia

Major Sponsors
Kulturstiftung des Bundes,
Kunststiftung NRW, Kulturstif-
tung der Westfälischen Provin-
zial Versicherung, Sparkasse
Münsterland Ost
Partners
RWE Westfalen-Weser-Ems, T-
Mobile and Fa. Beresa, Münster,
in Cooperation with
DaimlerChrysler AG, Ströer,
Krüger und vitra
Project Sponsors
Sparda-Bank Münster, West LB,
Mr. and Mrs. Andreae-Jäckering,
Deutsche Bank, Stadtwerke

Münster, M:AI Museum für
Architektur und Ingenieurkunst
NRW, Kulturstiftung Westfalen-
Lippe and HTC smart mobility
State Support
Henry Moore Foundation,
Association française d'action
artistique (AFAA), Ministry of the
Flemish Community, SEACEX
(Sociedad Estatal para la Acción
Cultural Exterior), CNAP-Fonds
national d'art contemporain
(Ministère de la culture et de la
communication), British Council,
Mondriaan Foundation
Special Thanks to
Brillux, Fa. Brück , BSW Anlagen-
bau GmbH, Aloys F. Dornbracht
GmbH & Co. KG, Heinzig
Metalltechnik GmbH, Butter-
handlung Holstein, Kaufleute
vom Prinzipalmarkt, KM Europa
Metal, Fa. Kotte, Hotel Mauritzhof,
NEWI, Meta-Regalbau, Gebr.
Niessing GmbH & Co., Pebüso
Betonwerke, Porzellan-Manufak-
tur Nymphenburg, Quitmann –
Freude am Radfahren, Sandisk,
Villeroy & Boch

Welcome to the Grand Tour 2007
52nd International Art Exhibition
of the Biennale di Venezia, Art 38
Basel, documenta 12, skulptur
projekte münster 07 are pleased
to invite you to the Grand Tour of
the 21st century. www.grand-
tour2007.com to support the art
travellers.

The exhibition takes place under
the auspices of German Federal
President Horst Köhler.

Institutions of the exhibition

Major Sponsors

Sparkasse
Münsterland Ost

Sculptures of the former exhibitions

1977

01 **Donald Judd**
Ohne Titel
Lake Aa

02 **Claes Oldenburg**
Giant Pool Balls
Lake Aa

03 **James Reineking**
Synclasticon
Corner of Westhoffstr. and Langenbusch

04 **Ulrich Rückriem**
Dolomit (zugeschnitten)
Jesuitengang, near St. Peter's church

1987

05 **Dennis Adams**
Bus Shelter IV
Johannisstr.

06 **Giovanni Anselmo**
Verkürzter Himmel
Lawn near the Department of Theology

07 **Siah Armajani**
Study Garden
Institute of Geology garden

08 **Richard Artschwager**
Ohne Titel, Monument B
Torhaus, Schlossplatz

09 **Lothar Baumgarten**
Drei Irrlichter
Tower of St. Lamberti's Church

10 **George Brecht**
Three VOID-Stones
(one object realized) /
Schlossgarten, Einsteinstr.

11 **Daniel Buren**
4 Tore
(one gate remaining)
Domgasse, between Drubbel
and Domplatz

12 **Ian Hamilton Finlay**
A Remembrance of Anette
Alter Überwasser-Friedhof, Wilhelmstr.

13 **Ludger Gerdes**
Schiff für Münster
Horstmarer Landweg

14 **Dan Graham**
Oktogon für Münster
Schlossgarten

15 **Jenny Holzer**
Bänke
(Two of the original five still exist) /
Southern part of the Schlossgarten along
Hüfferstraße

16 **Rebecca Horn**
Das gegenläufige Konzert
Zwinger/Promenade

17 **Per Kirkeby**
Backstein-Skulpturen
Promenade in front of the palace

18 **Harald Klingelhöller**
*Die Wiese Lacht oder
das Gesicht in der Wand*
Inner courtyard of the Juridicum

19 **François Morellet**
*A la française (encore une fois):
Kreis, Quadrat und Dreieck*
Schlossgarten

20 **Matt Mullican**
Skulptur für die Chemischen Institute
Centre for Natural Sciences

21 **Giuseppe Penone**
Progetto Pozzo di Münster
Old cemetary Hörsterstr.

22 **Reiner Ruthenbeck**
Lodenfahne
Atrium of the WLW-Landesmuseum

23 **Thomas Schütte**
Kirschensäule
Harsewinkelplatz

24 **Susana Solano**
Muralla transitable
Buddenturm, Corner of Münzstraße /
Am Kreuztor

25 **Richard Tuttle**
Art and Music I+II
Fürstenberghaus –
Passageway to the Siegelkammer

26 **Rémy Zaugg**
*Versetzung des Denkmals „Knecht
mit Pferd" und „Magd mit Stier"*
Ludgerikreisel

1997

27 **Kim Adams**
Auto Office Haus
Aegidiistr.

28 **Janet Cardiff**
Walk Münster
LWL-Landesmusem, Domplatz entrance

29 **Huang Yong Ping**
100 Arme der Guan-Yin
Marienplatz

30 **Ilya Kabakov**
„Blickst Du hinauf und liest die Worte…"
Northern shore of Lake Aa

Further exhibitions in Münster